The Art and Style of
Western Indian Basketry

Text by Joan Megan Jones, Phd.

Maryhill Museum Collection

hancock

house

Copyright © 1982 Text Maryhill Museum
 © 1982 Photographs David Hancock
ISBN 0-88839-122-6 Hancock House Edition
ISBN 0-88839-124-2 Maryhill Edition

This book is simultaneously published in an edition
for the Maryhill Museum of Art and in the
publishers trade edition.

Designed by H.W. Freer

All rights reserved. No part of this publication may be reproduced,
stored in a retrieval system or transmitted, in any form or by any
means, electronic, mechanical, photocopying, recording or otherwise,
without the prior written permission of Hancock House Publishers.

HANCOCK HOUSE PUBLISHERS LTD.
19313 Zero Avenue, Surrey, B.C., Canada V3S 5J9
HANCOCK HOUSE PUBLISHERS
1431 Harrison Avenue, Blaine, WA, U.S.A. 98230

TABLE OF CONTENTS

FOREWORD

The Native American basketmaker was totally and intimately involved in all stages of creation from the first mental concept through the gathering and preparation of materials to the completion of the last stitch. Basketmaking was an incredibly personal art, and the finished product reveals, in the evenness of its materials and the perfection of its stitching, the harmony of hand and mind in its creator. But beyond this, the Native American basket reveals a wider harmony between the weaver and the universe, a world where man was a part of, rather than apart from, nature. This world view was devastated by the impact of European culture, which saw nature in terms of conquest rather than cooperation. Basketmaking survived the confrontation, and, indeed, survives today. It is a melancholy, anachronistic existence artificially prolonged in a hostile environment. Like the Hawaiian language on Oahu, it has become an object of scholarly curiosity and of commerce. We should be thankful, nonetheless, that basketmakers still ply their trade. For as long as they remain faithful to the old traditions and materials, their works will serve as reminders to an alienated civilization of the beauty that can be achieved when the environment is touched with gratitude and care.

I would like to express my thanks to Dr. Joan Megan Jones for this first published work on the Maryhill collection. Thanks are also particularly due to Dorothy Brokaw, under whose administration the Maryhill basketry collection was given the importance it deserves; and to Harvey W. Freer, curator and artist, whose design for the exhibition facilities has at last brought the greater part of the Maryhill collection before the public.

David Coomler
Associate Curator
Maryhill Museum of Art
August 27th, 1981

INTRODUCTION

By the time that white explorers, traders, and settlers reached the Indians of western North America, basketry traditions were long established. Baskets were made for use in nearly all daily activities, and a great variety of types were made by different tribes. Traditions and styles evolved and changed before the advent of the white man and continued to change at a more rapid pace under the pressures and influences of trade and settlement. The period beginning in the late 1800s and continuing to the early 1900s generally marks the time of great productivity in basketmaking and the beginnings of collecting. Baskets made during this period comprise the bulk of museum and private collections. After the 1920s basketmaking declined in many areas, but collection of old specimens continued. Even though baskets are still being made today in many parts of the west, most collectors prefer the older "traditional" style to the more modern, "untraditional" style showing the influence of white contact.

The baskets in the Maryhill Museum collection encompass both the older traditions and some examples of styles influenced by white cultural contact. Some collectors and critics judge modern baskets inferior or "degraded" in comparison to the "pure" earlier styles. Others disagree, and see an exuberant, free quality in modern styles.

Although each basket is unique, there are similarities in a group of baskets from the same tribe. Each group of weavers follows a set of rules in the selection of materials, construction techniques, shape, design motifs, and methods of applying decoration. It is the distinctive combination of these features which creates a tribal or regional style, and it is by examining these features that a basket may be attributed to a certain tribe or region.

All baskets are either woven or sewn. Woven techniques involve upright fiber peices and horizontal peices which are worked around the uprights in some fashion. Varieties of woven techniques are:

Checker Twill Plain twined 5

Diagonal twined Three-strand twined Wrapped twined

Lattice twined Wicker

Sewn or coiled baskets consist of a foundation coil made up of thin pieces of wood or bunches of grass. The coil is wrapped and sewn by a thin, strong, flexible fiber such as split root, reed, or grass. Coiled varieties differ in the make-up of the foundation, and the methods of sewing the coils are as follows:

 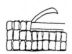

One rod foundation Splint or slat foundation

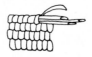 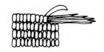

Three rod foundation Bundle foundation

Stitching of the coils is done in one continuous spiral except for slat foundation coiling which is sewn in parallel discontinuous rows. There are several common ways to sew the coils:

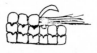

Split stitch Close-set or widely-spaced

The weaver molds and forms the materials of the basket as she works, always with a specific shape in mind for the completed basket. All shapes are derived from circular or rectangular forms, with circular variations being by far the most common.

Baskets intended for hard, constant use are often undecorated, but most baskets have some form of decoration. Designs are woven in during construction, and limited by the nature of construction, requiring for their creation a repetition of the same basic unit of stitch by which the basket is woven. Designs are most commonly rendered in a color contrasting with the background, and are strongly geometric, angular and linear due to the constraints of the technique. Painted decoration is used on the Northwest Coast and by the Hopi.

Basketmaking achieves the status of art when the creation is a harmonious whole resulting from the perfection of materials and construction techniques. No flaw in materials or stitching distracts the eye from the appreciation of shape and surface design in such baskets.

This book is intended as an introduction to the styles and techniques of the Native basketry of Western North America as exemplified by the collection of the Maryhill Museum of Art.

Aleut

Aleut weavers who live on the island chain off the coast of the Alaskan mainland make particularly fine twined baskets. Using only wild grasses, these weavers create soft twined bags, wallets, and cylindrical baskets of extraordinary delicacy. Some of the finest pieces resemble linen cloth. Techniques of plain twined as well as open- and cross-warp twined are prevalent. Delicate designs are false embroidered in wool yarn or silk threads on the basket surface.

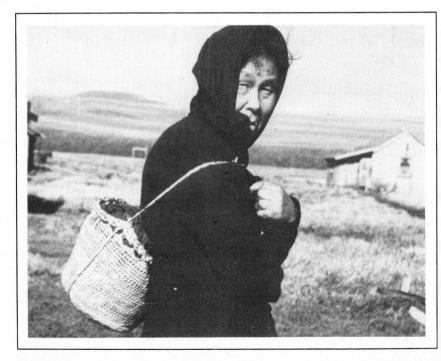

Old Aleut weaver.

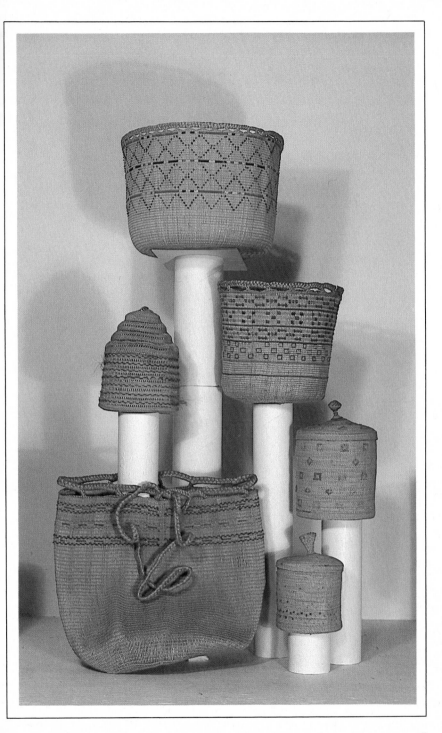

Aleut grass baskets with false embroidery designs.

Tlingit

Tlingit Indians of southeastern Alaska make a distinctive style of twined spruce root basket. Plain twining is the major technique, but other varieties of twining are used for decorative effect or sometimes for reinforcement at the base and rim of a larger basket. Common shapes are cylindrical, with either straight or flaring sides. Another shape resembles an urn. Tlingit weavers nearly always follow the same basic structure for basket decoration. Designs are small geometric figures consisting of triangles and squares arranged in horizontal bands on the surface. The designs are subtly colored with vegetal dyes (or more recently with harsher aniline dyes), and are woven in as the basket is being constructed.

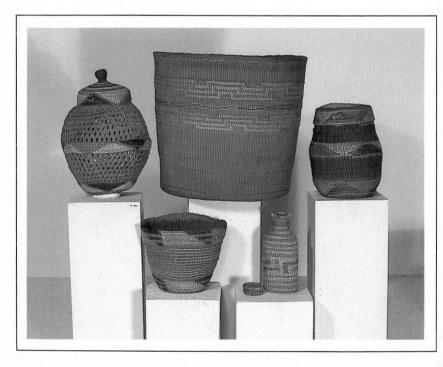

Tlingit ornamental baskets show false embroidery.

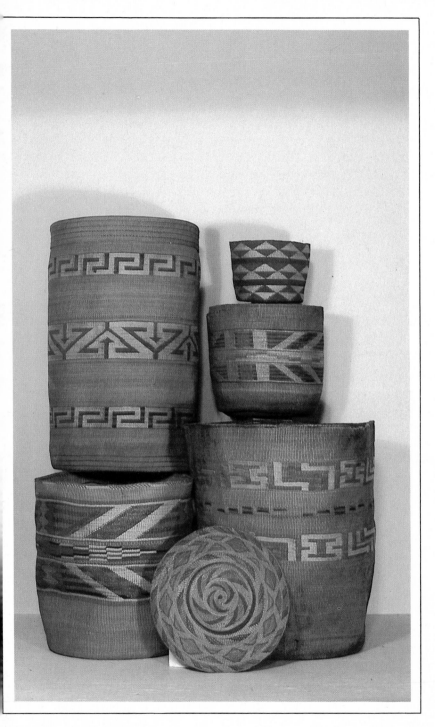

Tlingit berry and storage baskets.

Haida

Haida weavers, from the Queen Charlotte Islands, make a basket type similar in construction and shape to the Tlingit style, but distinctive in its decoration. The straight-sided cylindrical basket of plain twined weave has alternating horizontal bands of black and tan. The top two or three inches of the baskets are woven in two strand twilled twining.

Tsimshian

Tsimshian baskets, from the northwest British Columbian coast, are similar to Tlingit baskets in construction and decoration but are made of cedar bark instead of spruce root, which gives them a different appearance. A basket twined of cedar bark has a reddish color and a soft texture. In contrast, twined spruce root baskets are a light tan color and have a shinier, harder surface.

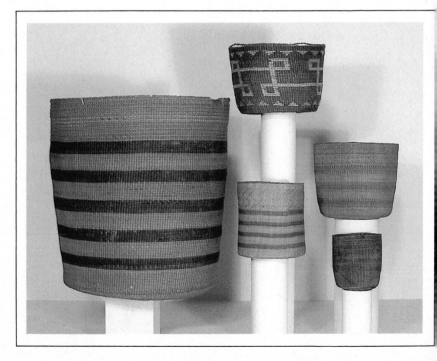

Cedar bark Tsimshian basket on top, Haida spruce root baskets on bottom.

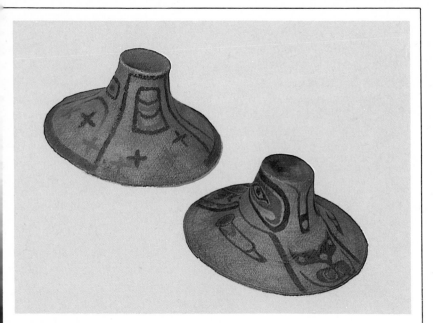

Painted Haida hats.

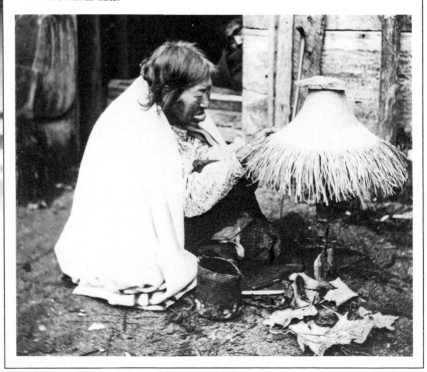

Old Haida weaver.

Nootka & Makah

Nootka and Makah weavers, two closely related groups from Vancouver Island and northwest Washington respectively, produce baskets in a twined weave known as wrapped twining. Small round or square baskets with covers and rectangular bags with handles are common. Unusual shapes modeled after items obtained in trade from white settlers are popular with Nootka and Makah weavers. Glass bottles are covered over with basketwork. Nearly all baskets of the Nootka-Makah style have brightly colored designs contrasting with a cream-colored background. Weavers purchase chemical dyes to achieve these intense colors.

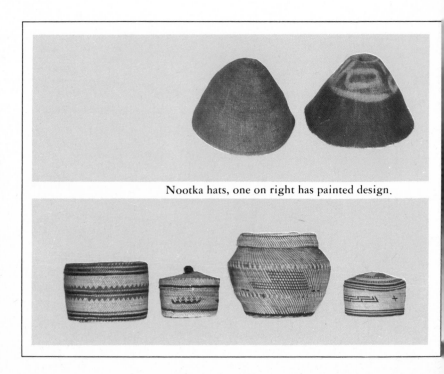

Nootka hats, one on right has painted design.

Nootka/Makah trinket baskets showing wrapped twining.

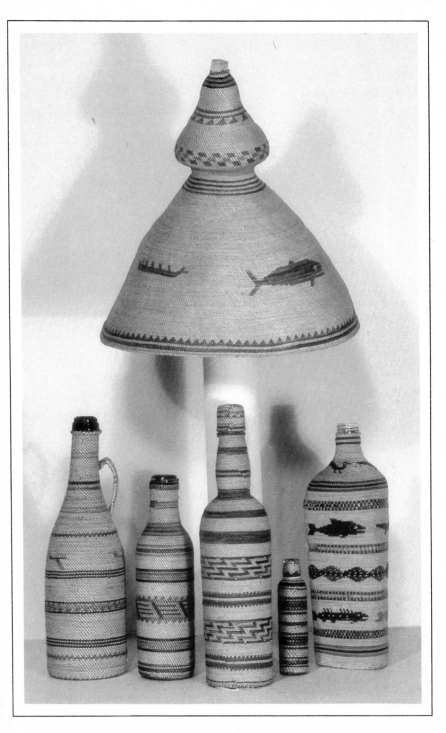

Nootka/Makah wrapped twined bottles and hat.

Chehalis and Columbia River

Chehalis baskets, from the southwestern region of Washington, usually have designs of human figures on the surface. Fine twined wallets, often having designs of stylized human and animal figures, were made in the early part of the nineteenth century by tribes living along the Columbia River.

Quinault

Quinault weavers of the Washington coast make twined baskets having slightly curved sides. The basket body is usually covered with a simple design of vertical stripes or alternating light and dark squares.

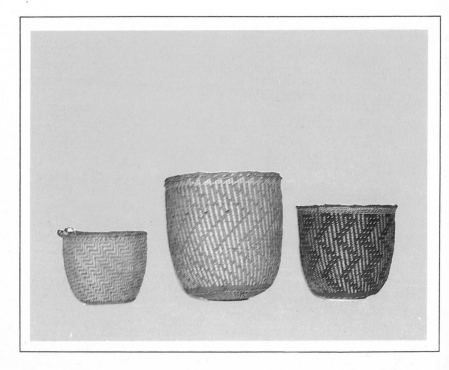

Quinault baskets.

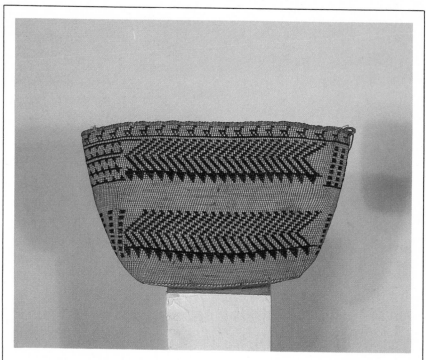

Chehalis basket.

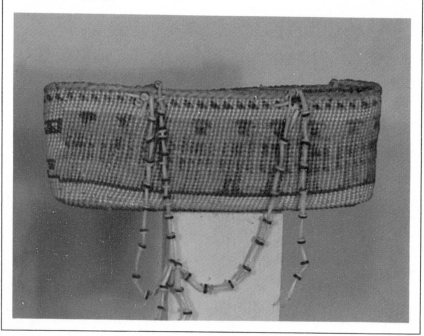

Columbia River basket.

Skokomish

Skokomish Indians, who live along the Hood Canal in Washington, make a distinctive twined, basically cylindrical basket. The grasses and reeds used in construction give this style a soft, flexible appearance in contrast to the stiff quality of the Quinault baskets. Decoration on these twined baskets consists of broad bands of geometric designs arranged vertically or diagonally on the body and a separate design of a stylized animal figure around the rim.

Twined and Checker Work

Several tribes of the northwest coast region make rectangular, boxlike baskets and flat bags of checker weave using strips of cedar bark. These flexible, lightweight baskets are used to store such things as clothing and utensils. In earlier days, baskets like these were used as trunks to hold clothes and tools when people went by canoe to fish or to visit a neighboring village.

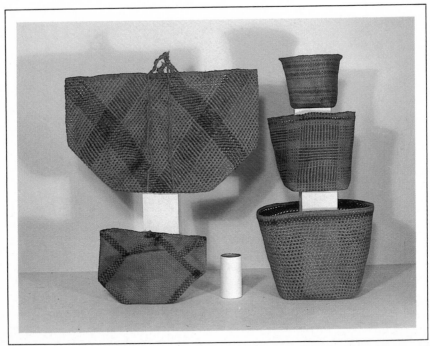

Twined and checker work.

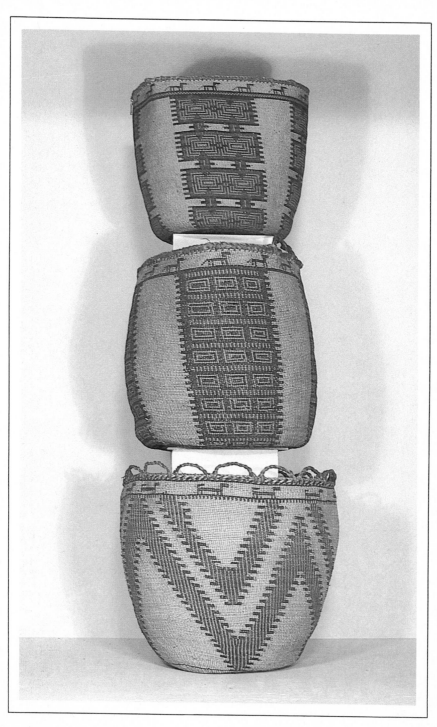

Skokomish storage baskets.

Northwest Twining

Wasco

Wasco weavers in the lower Columbia River region make cylindrical, soft, flexible bags twined of hemp and cornhusk. Many of these "Sally bags," as they are known, have woven designs of geometric shapes, but others have designs of stylized human and animal stick figures. These figures are similar to the ancient petroglyphs, or rock carvings, found along the Columbia River Gorge.

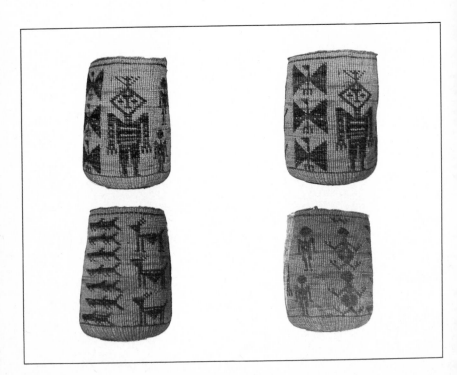

Wasco Sally bag showing six columns of designs.

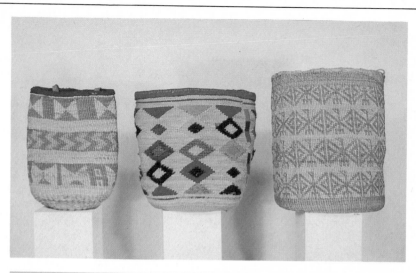

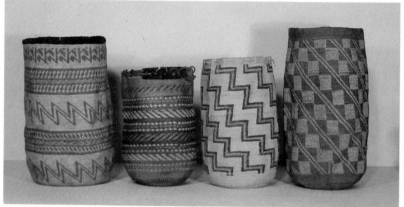

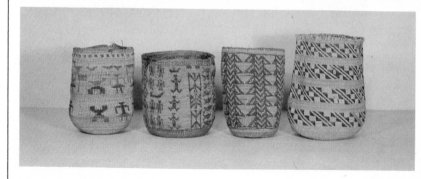

Wasco Sally bags.

Salish (British Columbia)

Salish tribes in British Columbia make variations on rectangular shapes with straight or flaring sides. Weavers use either a bundle or slat foundation. Large, covered, rectangular storage baskets resembling trunks are made with a slat foundation. Salish weaving techniques permitted the construction of baskets which, when soaked, would become water-tight, and could be used in a method of cooking which utilized hot stones placed in the container.

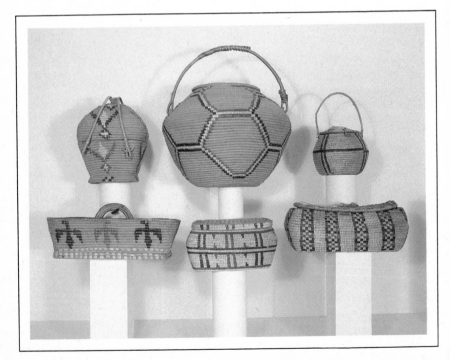

Salish trinket baskets with imbricated design.

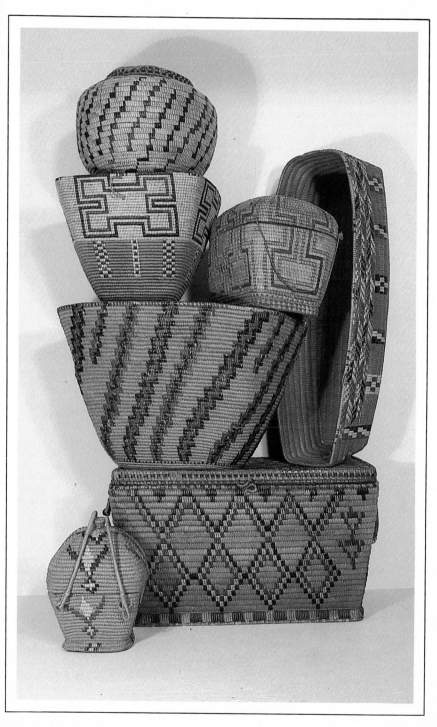

Salish burden and storage baskets.

Chilcotin

Chilcotin weavers of interior British Columbia adapted Salish coiling techniques and shapes but added some unique features of their own. First, the rectangular shape is deeper in proportion to the width, and curves slightly inward toward the rim. Second, nearly all baskets have a thin wood rod that is shaped, bent, and sewn on the body below the rim. Finally, many of the Chilcotin baskets have designs featuring stick figures of humans and animals.

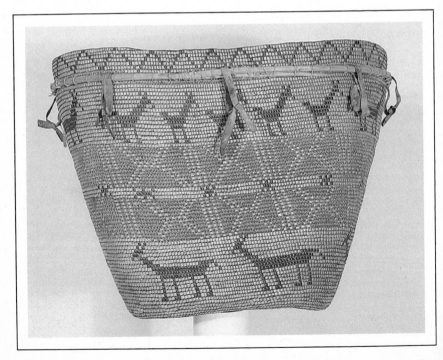

Magnificent Chilcotin burden basket.

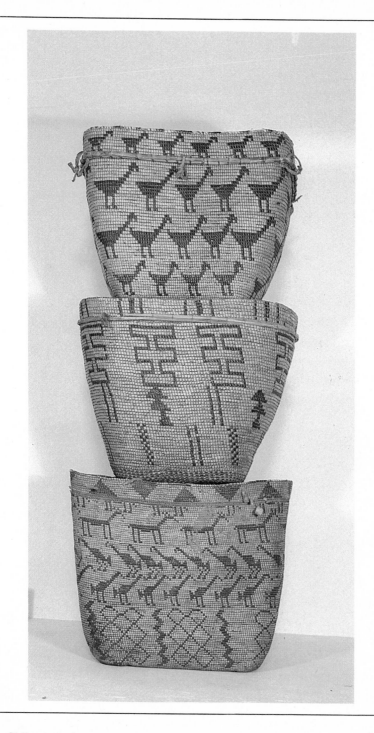

Chilcotin baskets.

Salish (Coastal Washington)

Salish weavers living west of the Cascade Mountains in Washington prefer a rounded, oval shape in making coiled baskets with a bundle foundation. Geometric designs are usually arranged in diagonal bands on the surface.

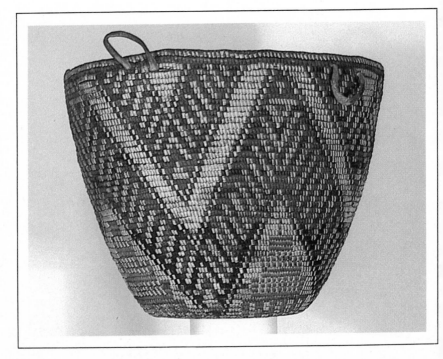

Fine imbricated basket from southern Coast Salish.

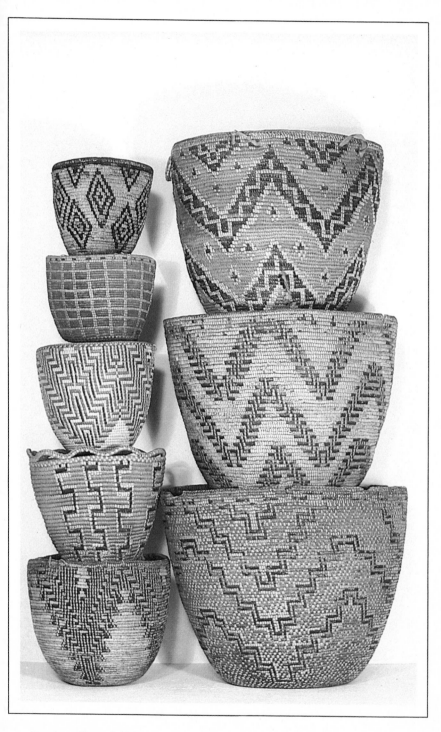

Southern Coast Salish imbricated baskets.

Salish (Interior Washington)

Klickitat, Yakima, and other tribes living east of the Cascade Mountains in Washington favor a deep cylindrical shape with flaring sides. Most baskets are finished off with loops at the rim. Another style made by Klickitat weavers features rows of open loop work made by wrapping a bundle coil foundation with the sewing strips and bending the wrapped coil at intervals to form rounded or triangular loops. The loop rows are fastened down with a row of regular stitched coils. Designs of diagonally arranged bands of geometric figures are common. Stylized representational designs are also seen.

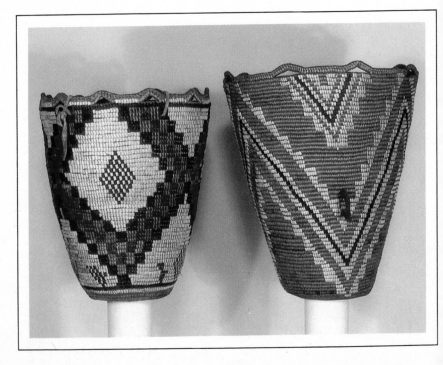

Fine Klickitat baskets with geometric designs.

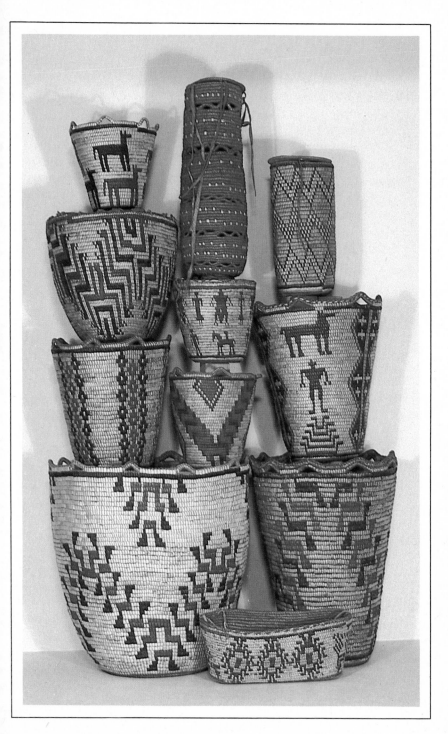

Klickitat imbricated baskets.

29

Hupa, Yurok & Karok

Like the Tlingit and Aleut, the Hupa, Yurok, and Karok weavers of northern California twist the contrasting strip for the design in such a way that the pattern is not visible on the inside of the basket. Designs on Hupa, Yurok and Karok baskets are usually bands of small triangles. The surface of small, bowl-shaped hats or caps is covered with tightly organized geometric designs.

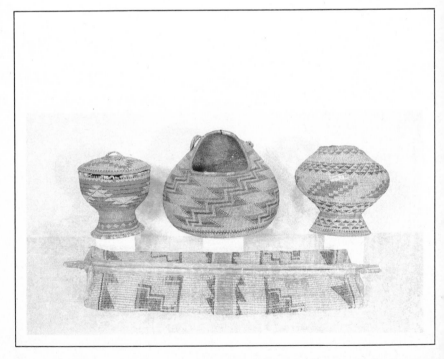

Northern California fancy twined baskets.

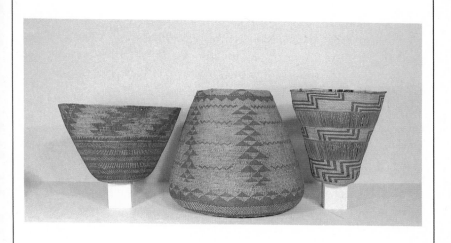

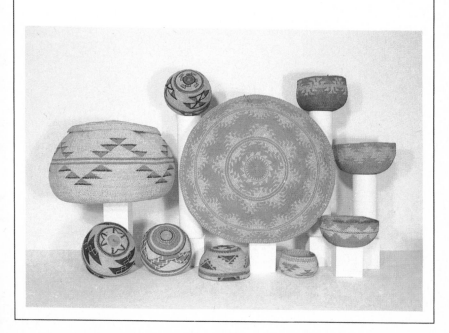

Twined basketry.

Klamath-Modoc, & Shastan

The weavers of northeastern California twist the contrasting design strip all the way around in a full turn so that the pattern shows through on the basket interior. Similarities between these and other tribes in the region make precise attribution of a given basket difficult.

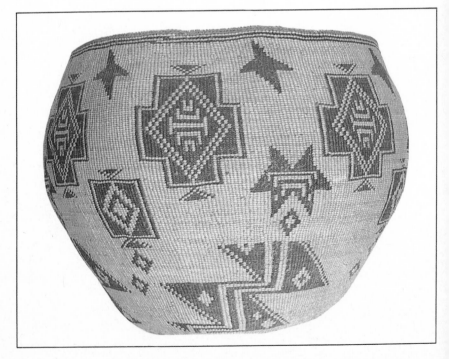

Fine Pit River twined basket.

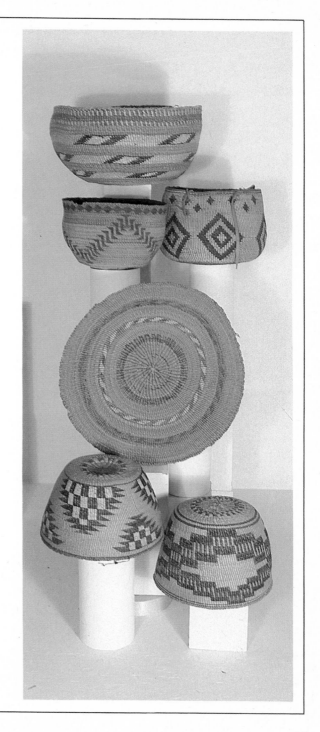

Fine twined baskets.

Oregon & California Twining

Pomo

Pomo weavers of central California make several different varieties of twined baskets. In addition to plain twined weave, diagonal twined baskets are made. Large, conical, bell-shaped baskets of this weave serve as strong, durable carrying baskets. Designs are usually diagonal arrangements of small triangular figures. Pomo weavers have developed a technique of twining in which a thin rod is added to the outside surface and held in place with a wrapped weave. Baskets of this lattice weave are stiff and strong. Bowl shapes are common and sometimes pieces of shell and feathers may be attached to the surface for additional decoration. Large, open-twined baskets are made for use as storage cabinets.

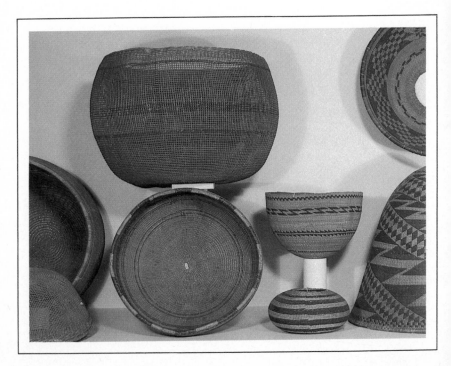

Fine twined Pomo baskets.

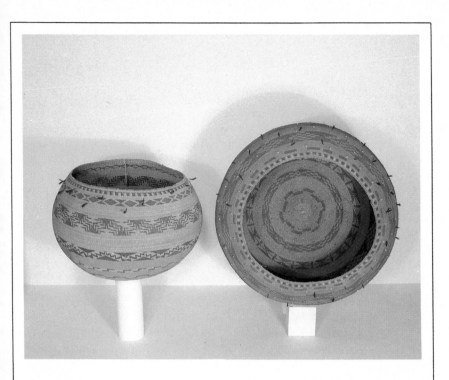

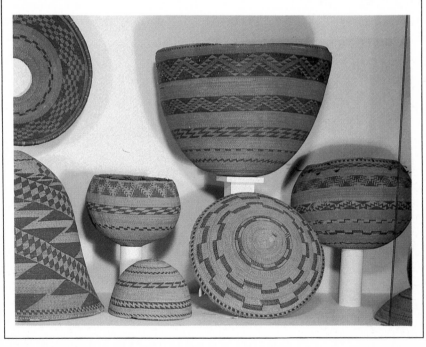

Pomo baskets.

Pomo & Maidu

Pomo weavers make a variety of coiled baskets, some with one rod and others with three rods. The difference between the two is seen in the stitches, which appear in an even line on the three-rod foundation but appear to be offset on the single-rod foundation, as each stitch is sewn around the rod below. Bowl, globe, and oval shapes with geometric designs are common.

The Pomo have created one coiled style unsurpassed in its use of color and texture. On small coiled bowls with a three-rod foundation, brightly colored feathers are inserted in nearly every stitch to completely cover the surface. Feathers from quail, duck, woodpeckers, and hummingbirds are used, ranging in color from white, yellow and red to blue, brown, and black. White shell beads are sewn around the rim, threaded on string to make a handle, and, along with pieces of cut abalone shell, hung in pendants from the body. These vibrant, exciting baskets are made as special gifts and considered great treasures.

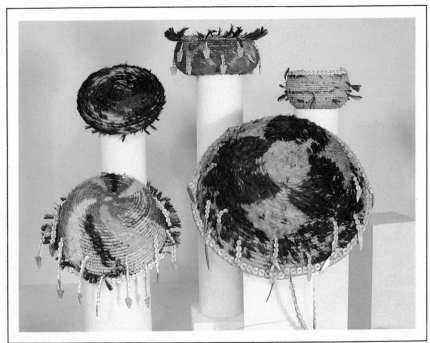

36 Pomo coiled feather baskets.

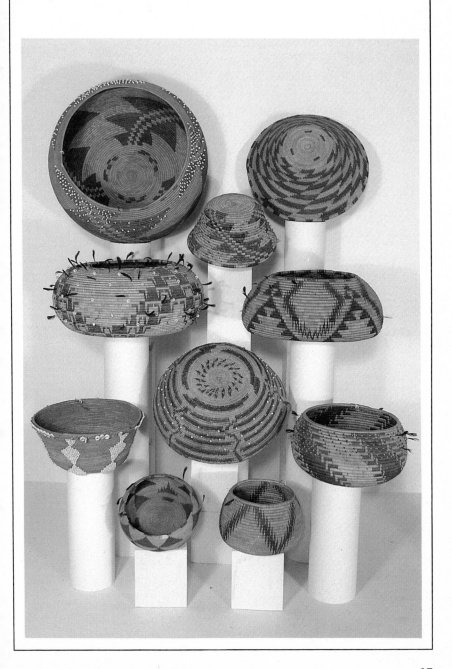

Pomo and Maidu coiled baskets.

Pomo & Maidu

Maidu, Wintun, and Miwok weavers in central California, east of the Pomo, make coiled baskets that usually have a three-rod foundation. One type is a large bowl with widely flaring sides and a design of diagonally arranged bands of small triangular figures. These weavers also make circular trays, small bowls, and globe-shaped baskets.

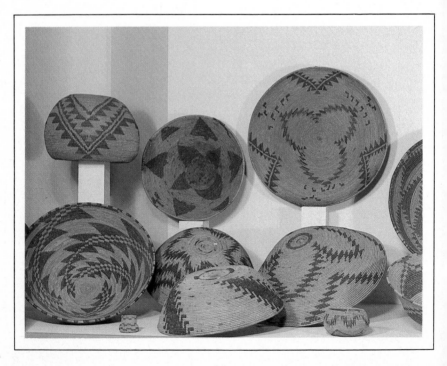

Central California baskets.

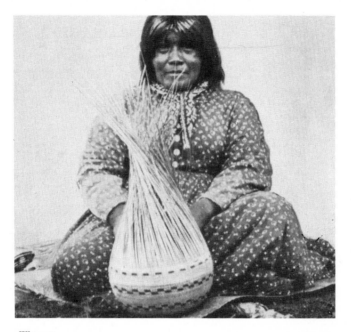

Pomo Weaver.

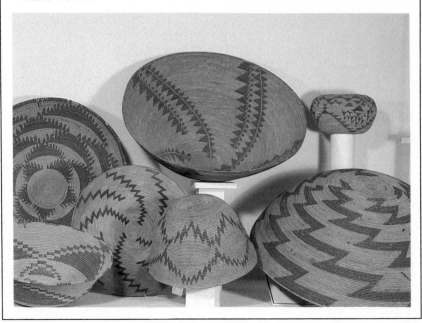

Maidu baskets.

Yokuts, Mono, Kawaiisu, & Tübatulabal

Yokuts and Mono weavers in the central valley of California use a thin bundle foundation for their coiled baskets. In addition to bowls and shallow trays, a distinctive basket called a bottleneck is made. The sides flare out from the base and then turn in abruptly to form a wide, flat shoulder from which a narrow, circular neck rises. Sometimes a row of feathers is placed around the widest part of the shoulder. A common design on baskets from this region is a horizontal band of triangular shapes in red and black contrasting with the light tan background of the body.

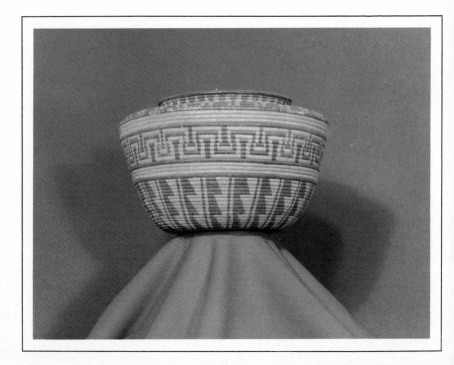

Bottleneck Yokuts basket.

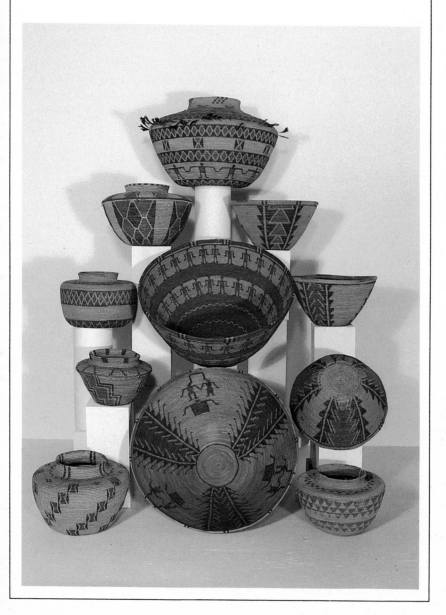

California coiled baskets.

Mission

Mission is the general name frequently used for baskets from the southern California region. Tribes of the region include the Diegueño, Luiseño, Serrano, Cahuilla, and others who make similar styles of coiled baskets. Characteristic styles of this region are globe and bowl shapes, both shallow and deep; coiling with a bundle foundation; and geometric designs. Some baskets have representational designs of plants, flowers, and animal figures.

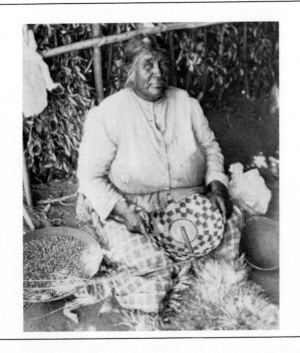

Mission Weaver.

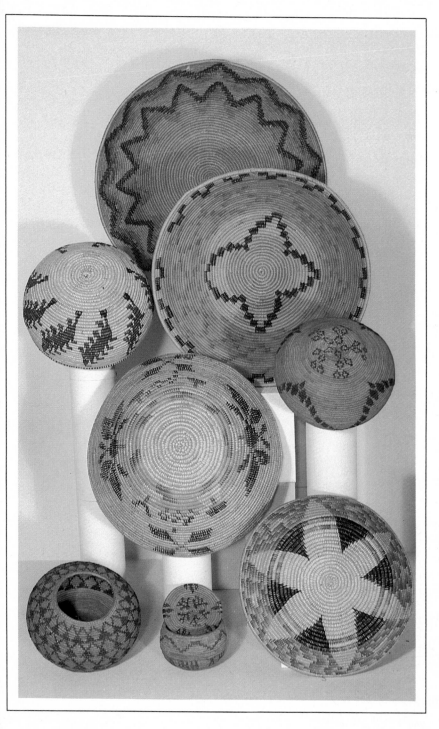

Mission Baskets.

Western Apache

Western Apache weavers make shallow bowls and large storage jars with a three-rod foundation. Designs on bowls consist of small geometric figures, and the rim and center are stitched with black fiber. Large, jar-shaped baskets, called ollas, some standing over three feet high, are used for storing food. In addition to geometric figures of crosses, diagonal lines, and rectangles, figures of humans and animals are used to decorate the surface area.

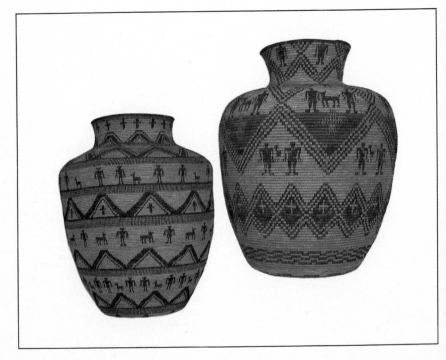

Western Apache olla or storage baskets.

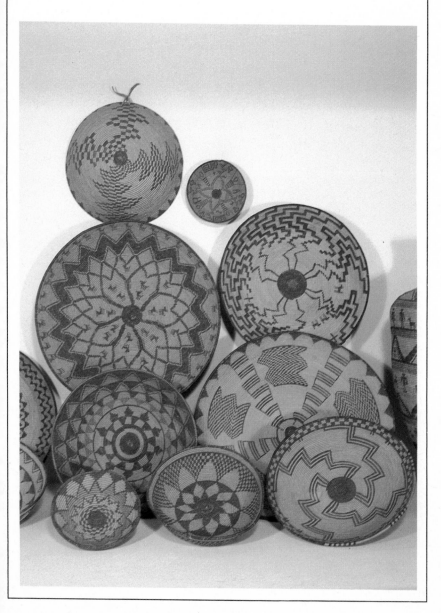

Western Apache coiled baskets and trays.

Mescalero Apache

Mescalero Apache basketry has a thin, flat coil. Designs on shallow bowls are simple geometric forms of brown on a light cream background

Jicarilla Apache

Jicarilla Apache weavers make coiled baskets having a foundation of three to five rods to make a stiff, thick coil. Designs of large, simple geometric forms in bright colors are common. In older baskets these bright colors may have faded over the years and now look soft and muted. Deep, cylindrical baskets have larger loops around the rim as well as loop handles. The Jicarilla Apache also make large, shallow bowls.

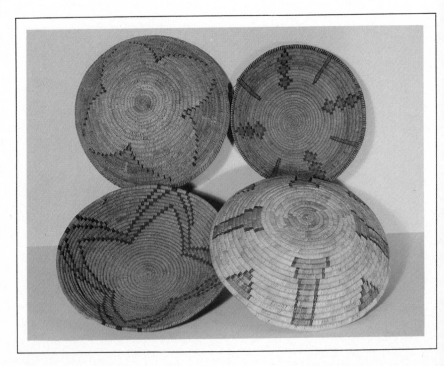

Mescalero Apache baskets.

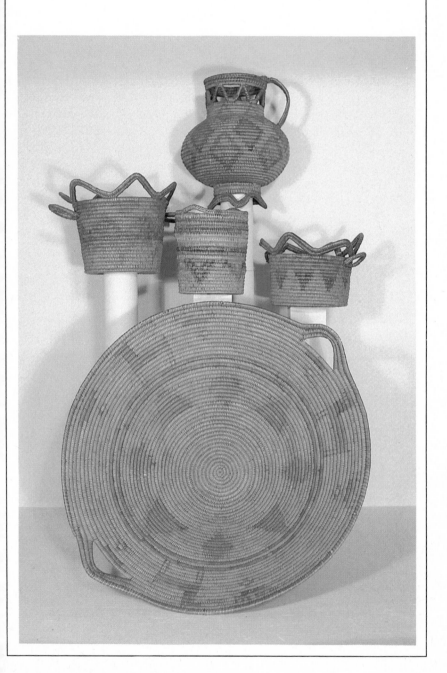

Jicarilla Apache coiled trays.

Pima

Pima Indians of Arizona make coiled basketry that is superficially similar to that of the Western Apache, but it is basically a separate, distinct style. One difference is seen in the foundation; the Pima use a bundle rather than a rod foundation, which gives the basket wall a flatter appearance than that of a Western Apache basket. Although both styles have a black rim and center, Pima designs consist of distinctive, closely arranged sets of zigzag and fret elements, and the Pima make a greater variety of shapes. In addition to shallow bowls and jar shapes, straight-sided cylindrical, oval, and rectangular shapes are made. Basket rims are often embellished with a row of bright blue beads, which are sewn on. The neighboring Papago and Maricopa Indians make styles similar to those of the Pima.

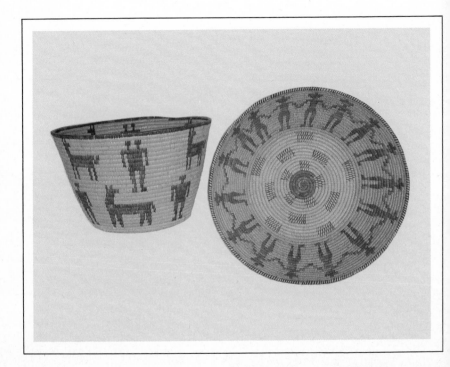

Pima zoomorphic design bowl and tray.

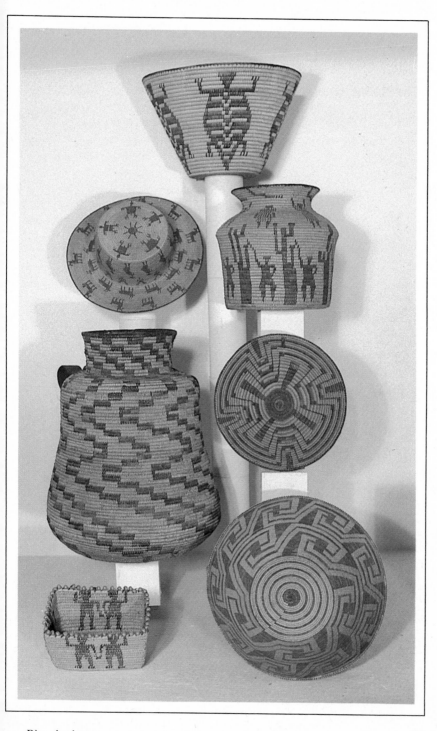

Pima baskets.

Ute, Navajo, Havasupai, & Yavapai

Navajo, Ute, Havasupai and Yavapai Indians of the Great Basin area make coiled shallow bowls and trays on a three-rod foundation. Decoration consists of fairly large-scale geometric designs. A distinctive style of tray was made for the Navajo wedding ceremonial. The design is always of the same form on these baskets and is composed of a broad, circular red band with black triangles spaced above and below it. A break appears in the design band, so the ring is not continuous.

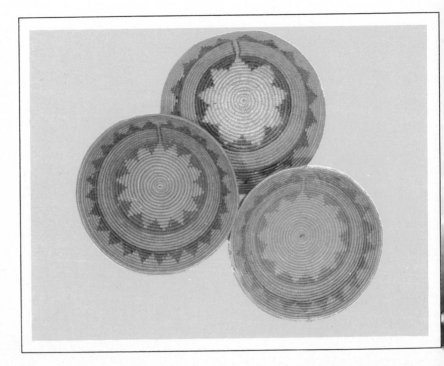

Navajo wedding trays.

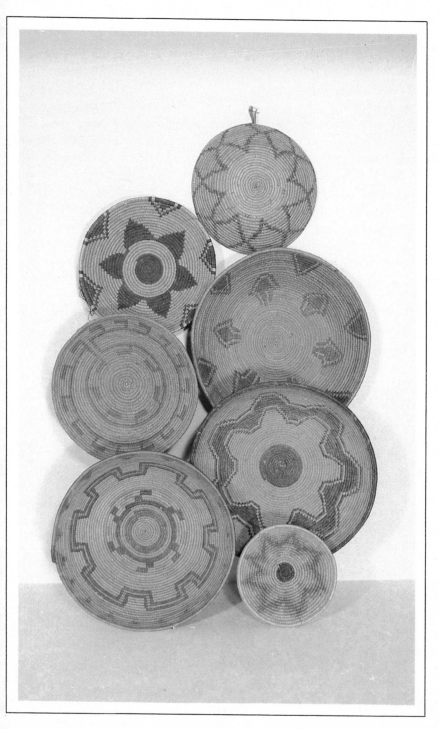

Three rod coil baskets of the Southwest.

Hopi

Hopi weavers make a coiled style of basket noted for the massive appearance of the bundle foundation. Bright primary colors covering broad areas make up the decoration. The quality of this style, resulting from the size of the coil foundation and the use of large areas of color, sets it apart from others, which are characterized by small, thin coils and tightly organized, small-scale geometric designs. Baskets of this style are circular, flat trays and globe-shaped bowls; some have covers.

Weavers of the Hopi village of Oraibi produce a wicker style of basketry; they are the only weavers in western North America to use this technique. Wicker is otherwise limited to the construction of very rough, crude utensils, such as harvesting trays and fish traps. The Oraibi wicker trays have a raised center section. Designs, often done in bold, bright colors, are either geometric or depictions of traditional ceremonial Kachina figures. Older baskets may now be faded and indistinct.

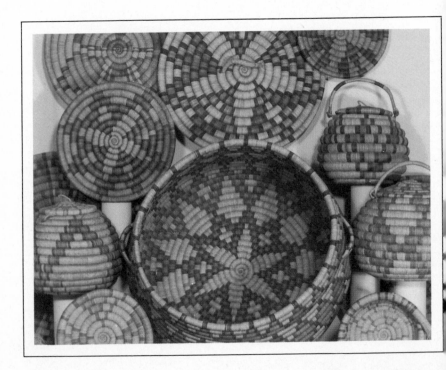

Hopi coiled baskets.

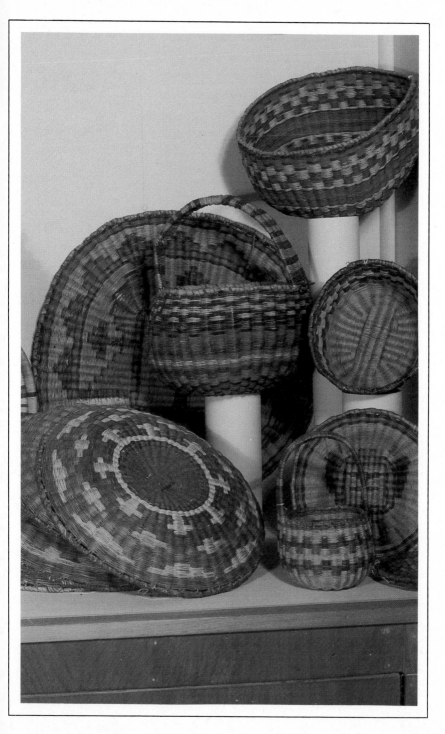

Hopi wicker baskets.

Undecorated Utilitarian Baskets

Varieties of plain, undecorated utilitarian baskets are made throughout western North America. Baskets are used to carry heavy loads over long distances, to collect food, to haul wood for cooking, to hold water, and even to hold babies. Baskets are used in nearly every step of food processing, and specialized basketry utensils are made, such as harvesting trays, seed beaters, mortars, cooking and serving bowls, and containers to store food.

Baskets began as functional containers, but Indian weavers in western North America have gone beyond basic utility to create objects of rare artistic quality. Skilled basketmakers strive for perfection in design, form, and technique, and their baskets are a stunning accomplishment in fiber art.

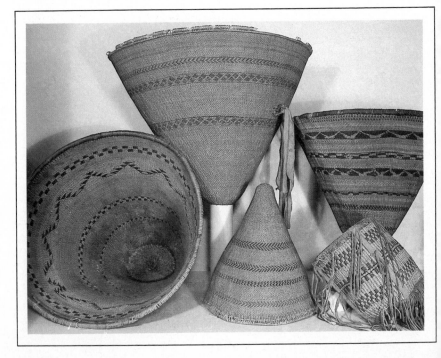

Gathering or burden baskets.

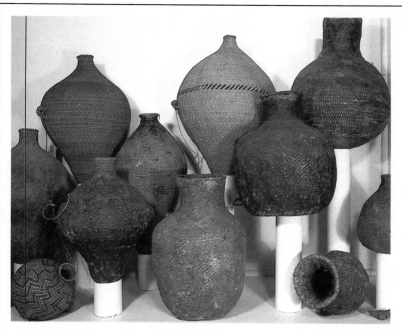

Water jugs, some sealed with pine pitch for waterproofing.

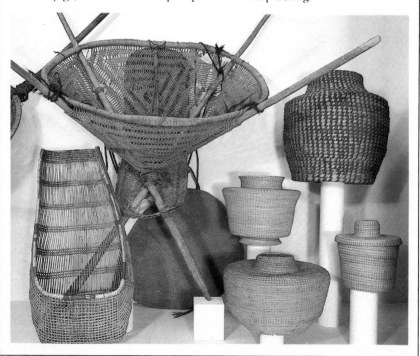

Miscellaneous utility baskets; storage, carrying and baby cradle.

Author's Note

The photographs in this book were taken at the Maryhill Museum of Art, located at the eastern entrance of the Columbia River gorge in Washington. Built by Samuel Hill in 1914, the museum houses European and American art, and includes a fine representation of Indian baskets from western North America.

Further Reading

Barrett, S.A.
 1908 *Pomo Indian Basketry.* University of California Publications in American Archaeology and Ethnology, Vol. 7, No. 3.

Haeberlin, H.K.; Teit, James; and Roberts, Helen.
 1928 *Coiled Basketry in British Columbia and Surrounding Regions.* 41st Annual Report of the Bureau of American Ethnology, Smithsonian Institution. Washington, D.C.

Jones, Joan Megan.
 1976 *Northwest Coast Indian Basketry: A Stylistic Analysis.* Ph.D. dissertation, University of Washington, Seattle. Ann Arbor, Michigan: University Microfilms, Inc.

 1977 *Basketry of the Quinault.* Quinault Indian Nation. Taholoh, Washington.

Kissell, Mary Lois.
 1916 *Basketry of the Papago and Pima.* Anthropological Papers of American Museum of Natural History, No. 17, Part 4. New York.

Lamb, Frank W.
 1982 *Indian Baskets of North America (Revised Edition).* Hancock House Publishers. 1431 Harrison Ave., Blaine, Washington.

Mason, Otis Tufton.
 1902 *Aboriginal American Basketry.* Annual Report of the United States National Museum, Smithsonian Institution. Washington, D.C.

O'Neale, Lila M.
 1932 *Yurok-Karok Basket Weavers.* University of California Publications in American Archaeology and Ethnology. Vol. 32, No. 1. Berkeley: University of California Press.

Paul, Frances
 1942 *Spruce Root Basketry of the Alaskan Tlingit.* U.S. Department of Interior.

PRINTED IN CANADA